HOSIE'S ZOO

Also illustrated by Leonard Baskin

HOSIE'S ALPHABET

HOSIE'S AVIARY

HOSIE'S ZOO

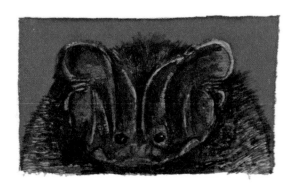

Pictures by
LEONARD BASKIN

*Words by Tobias,
Hosea, Lucretia, and
Lisa Baskin*

THE VIKING PRESS NEW YORK

The painting on the title page is of a barbastelle bat.

First Edition
Copyright © 1981 by Leonard Baskin
First published in 1981 by The Viking Press
625 Madison Avenue, New York, N.Y. 10022
Published simultaneously in Canada by Penguin Books Canada Limited
Printed in U.S.A.
1 2 3 4 5 85 84 83 82 81

Library of Congress Cataloging in Publication Data
Baskin, Leonard, date. Hosie's zoo.
Summary: Watercolors depicting the familiar as
well as the exotic in the world of animals.
1. Animals—Juvenile literature. 2. Animals—Pictorial
works. [1. Animals] I. Baskin, Tobias. II. Title.
QL49.B315 759.13 81-11672
ISBN 0-670-37968-9 AACR2

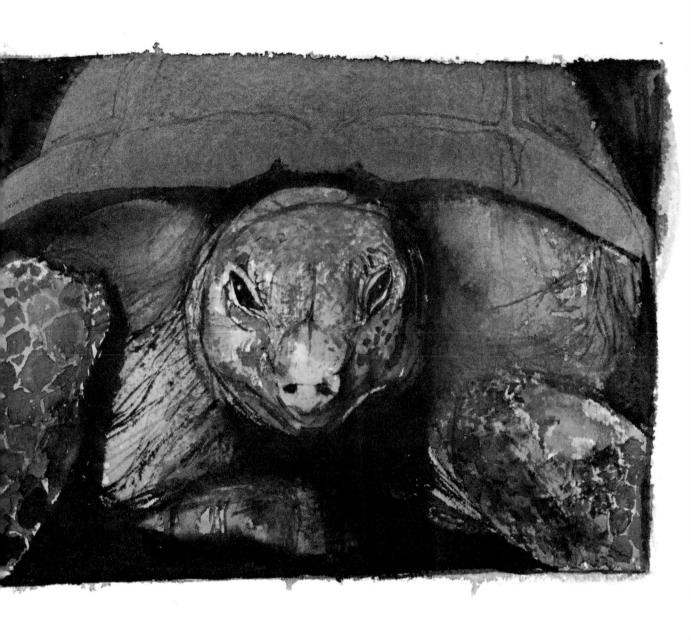

SEA TORTOISE

Behold the sea tortoise:
See its aged immensity withstand
The saltwater's rock-abrading
Ship-smashing embrace.

GIRAFFE

If you meet a giraffe
Be sure to have a ladder
And climb up all the way
To peer into those lustrous eyes.

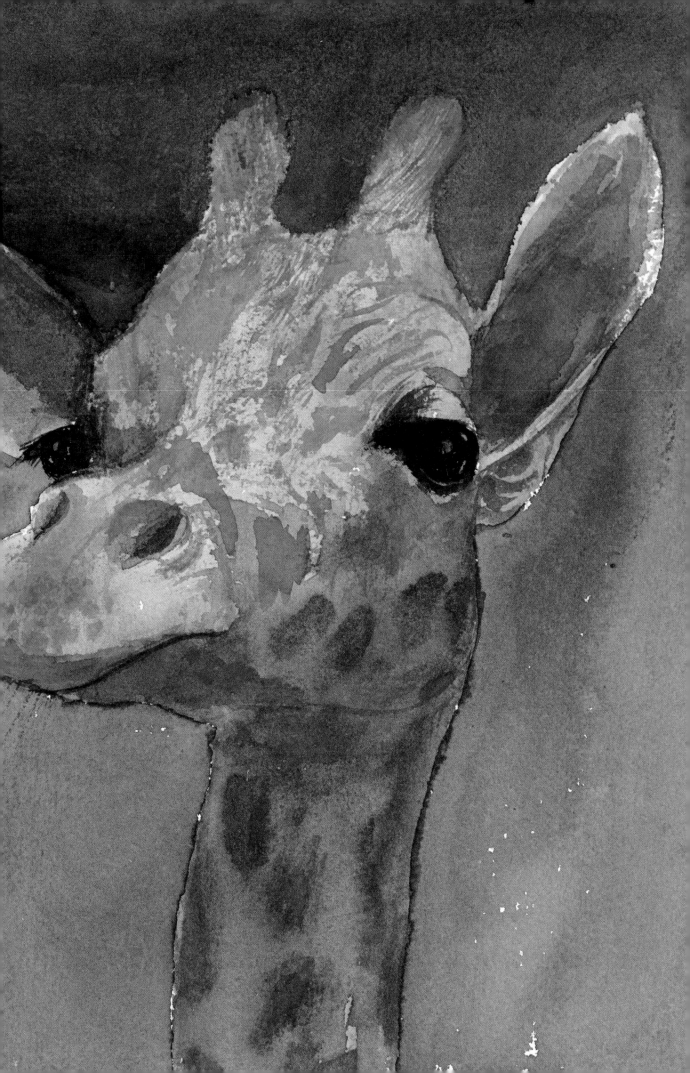

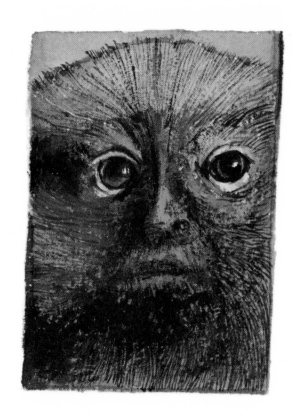

TITI

A rainbow
Flashes through the South American jungle.

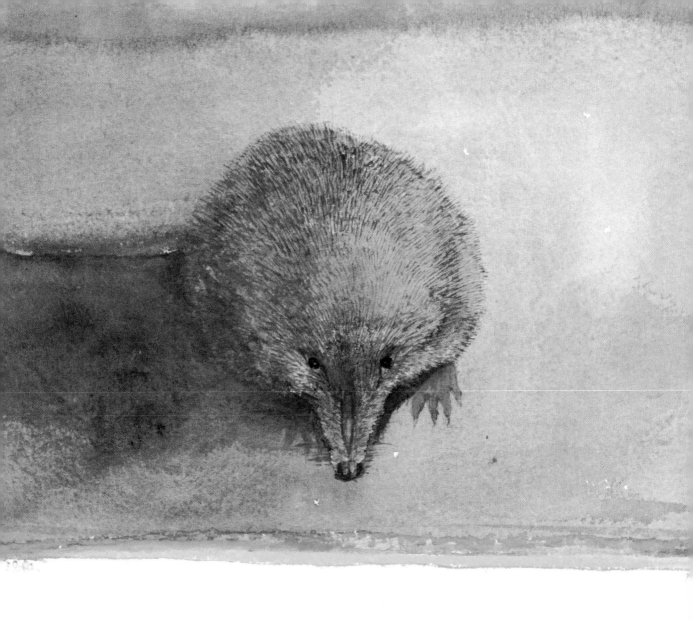

COMMON SHREW

Curled upon deft clawing paws
At dawn the common shrew begins to yawn
And rests from digging up your lawn.

COYOTE

"Sweet,"
Mutters the coyote,
"Is the taste of rotting meat."

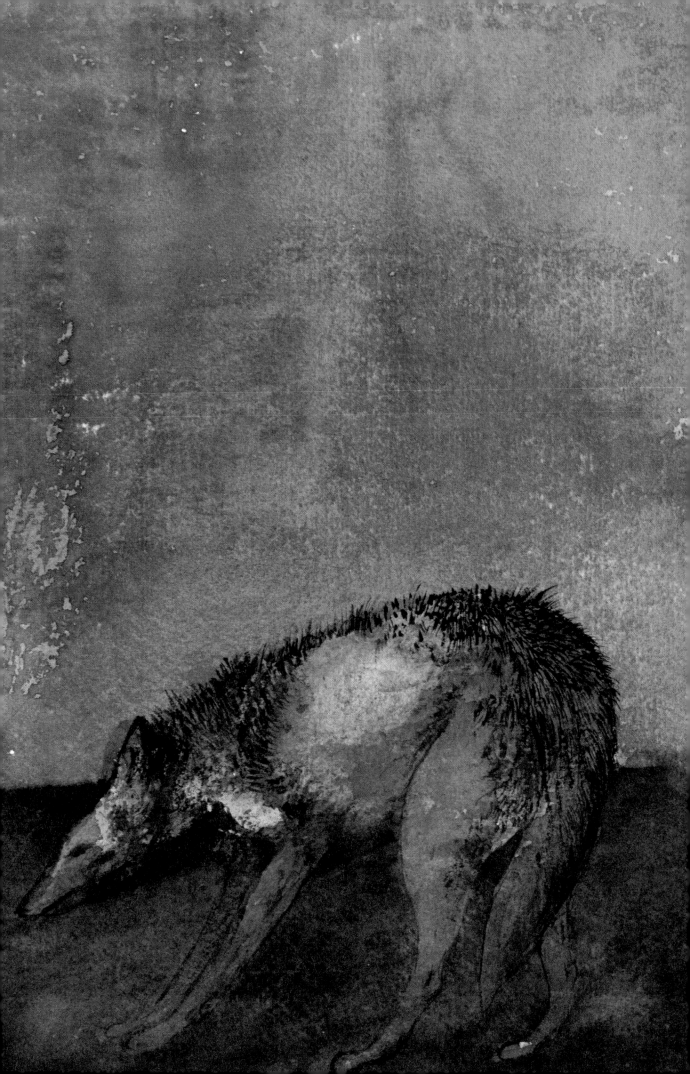

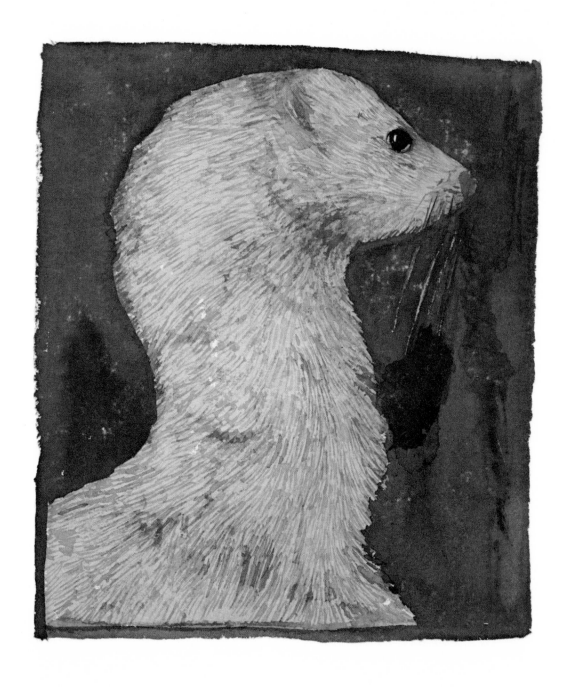

ERMINE

The slinky ermine preys
In gleaming winter fur
And soaks the farmyard mud
In blood.

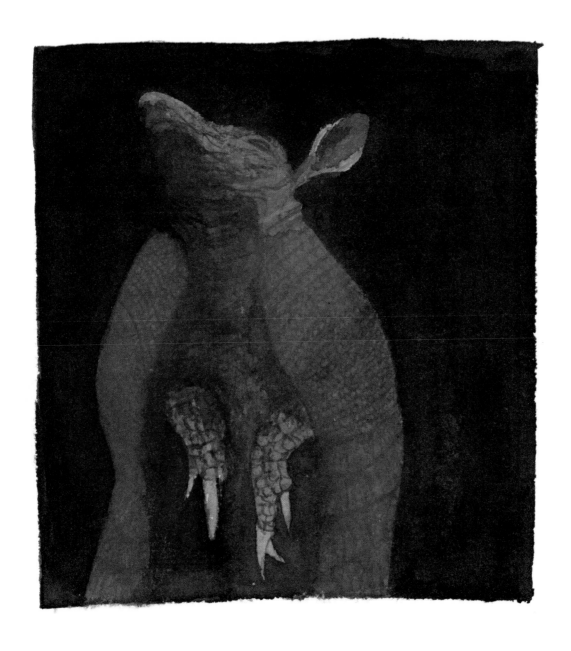

ARMADILLO

A builder of hard, hemispherical armor,
Insect digger on squat legs; but
Do you know a slow old armadillo from below?

BACTRIAN CAMEL

"Hey, Bactrian Camel,

 your humps are falling off!
Do they wilt from the heat?
Or flee from tyrannous captivity upon your back?"

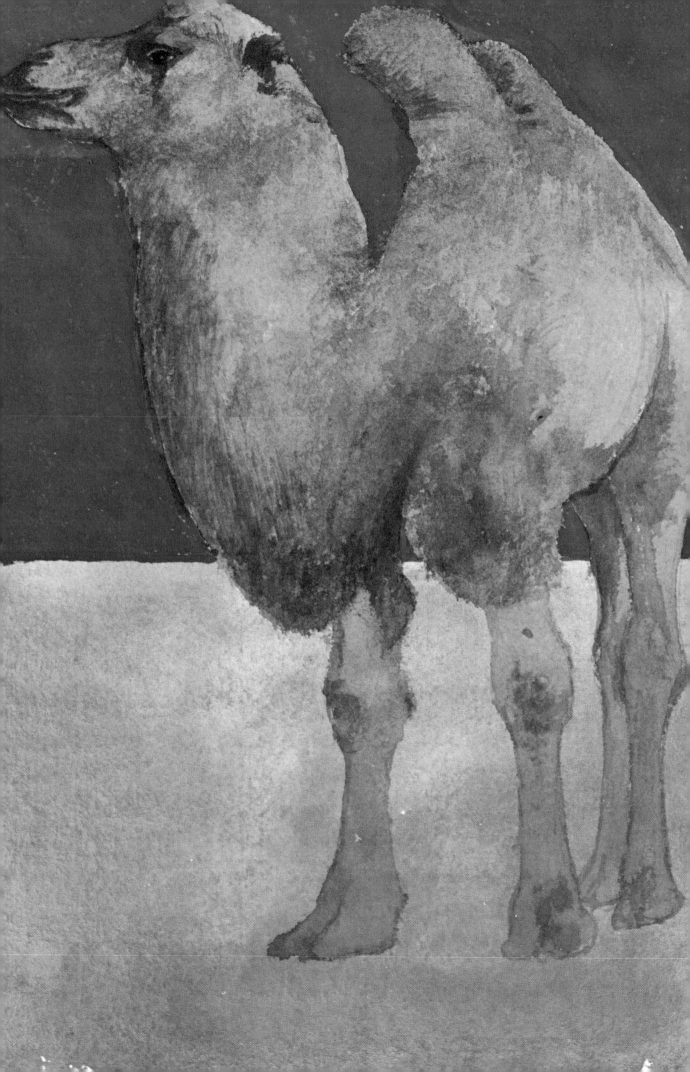

RHINOCEROS

The rhinoceros
Implores your caress
Trembling with monumental ardor.

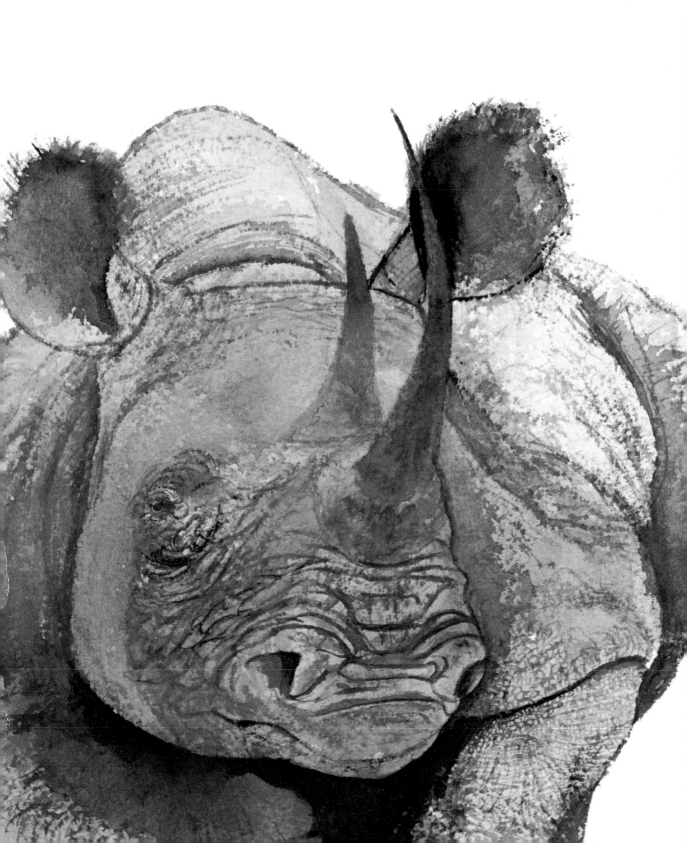

TIGER

The tiger
Boundlessly mighty
Sunders its jaws
And kills.

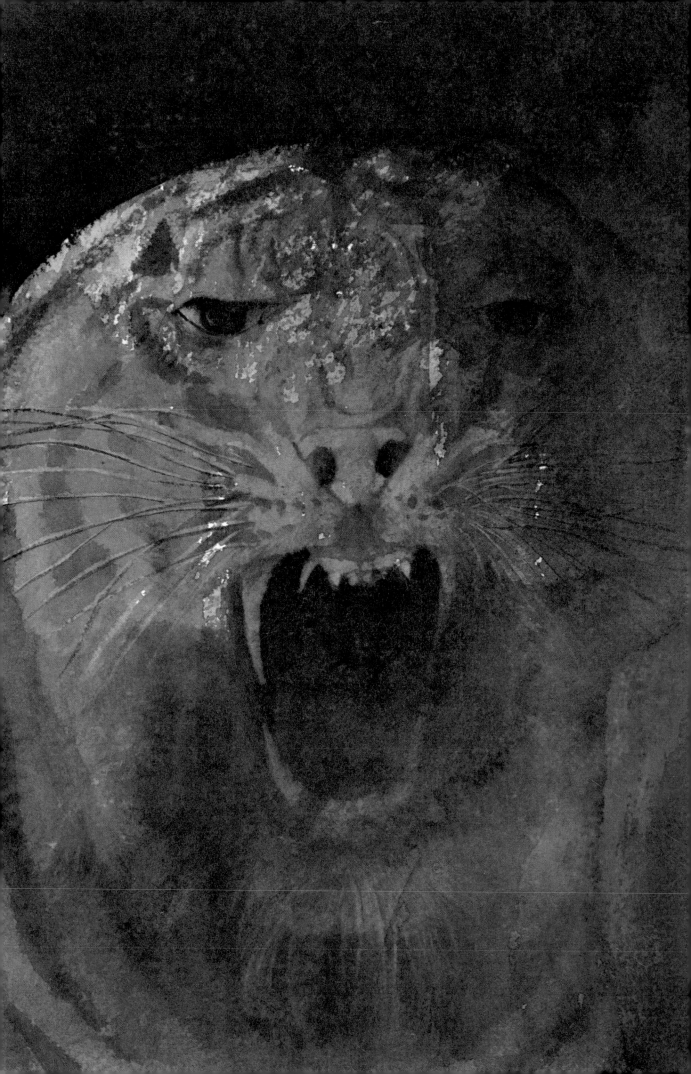

JACKRABBIT

The long-eared visible invisible jackrabbit.

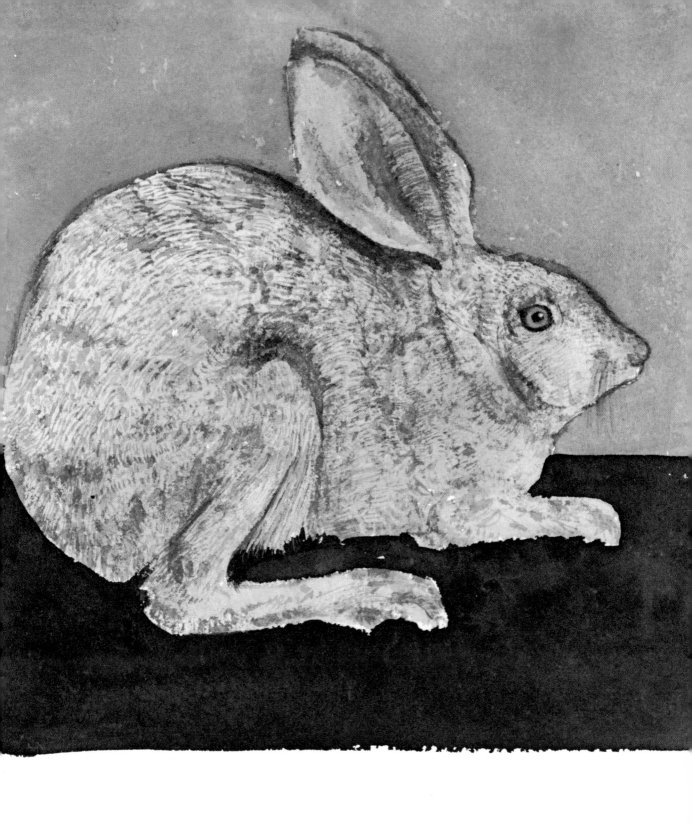

EAST AFRICAN HUNTING DOG

A harrowing predator:
 Only death strikes more surely
 Than a pack of these dogs.

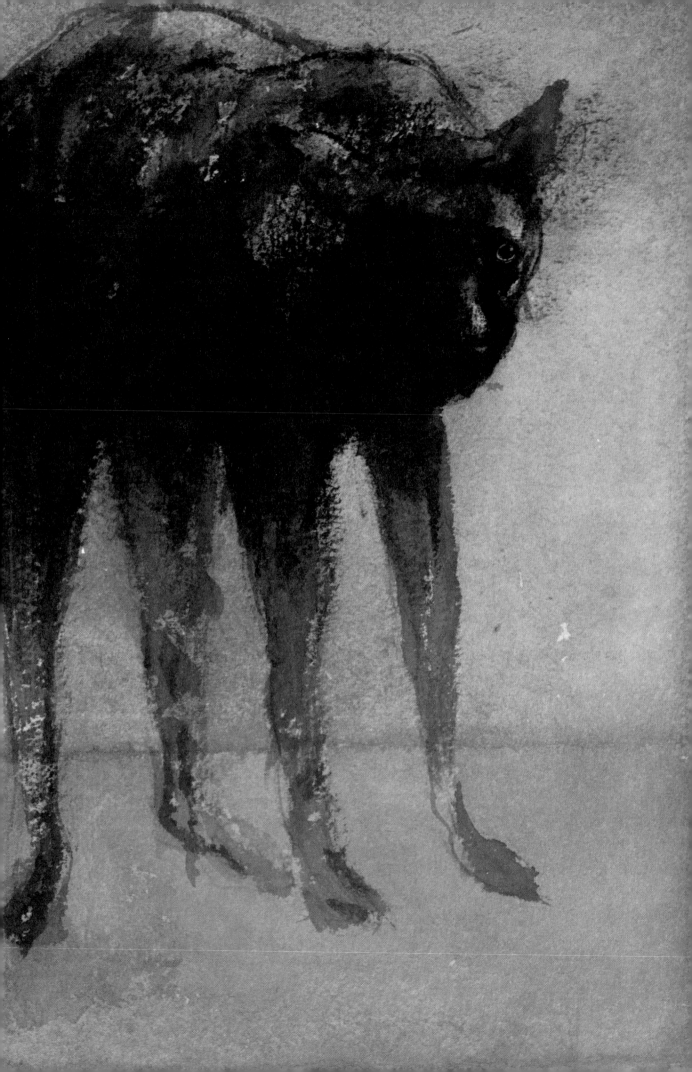

SLENDER LORIS

Thus the slender loris sits

 Having temper tantrum fits.

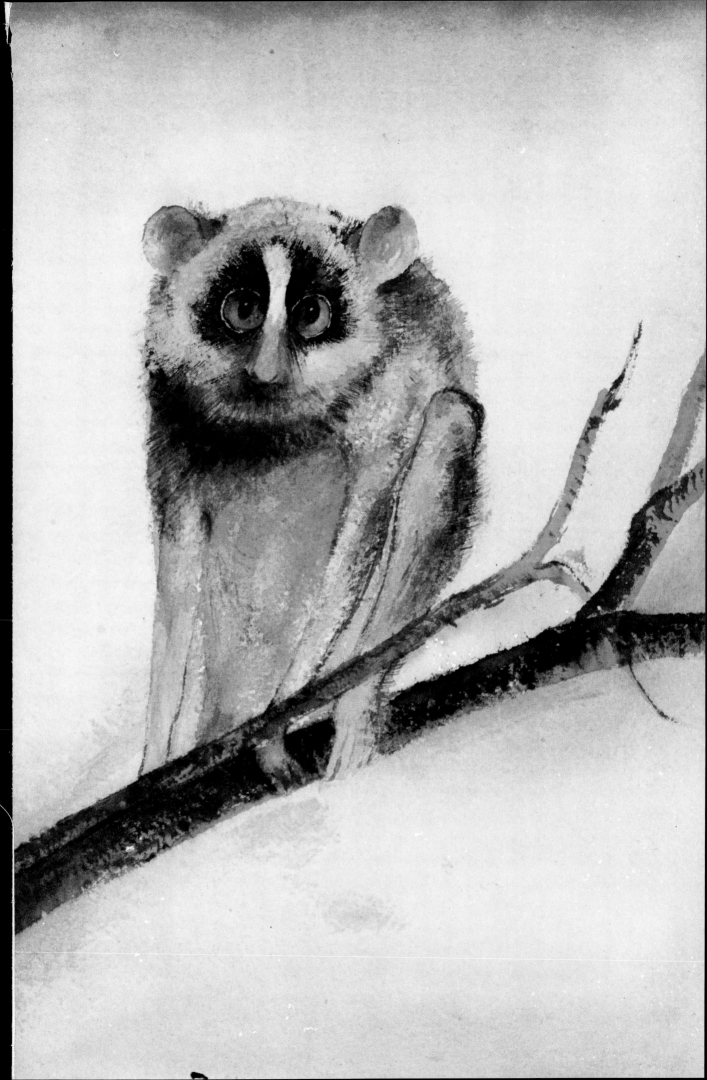

BIGHORN SHEEP

Wild reflections in keen eyes,
Nimble-footed on mountainsides.

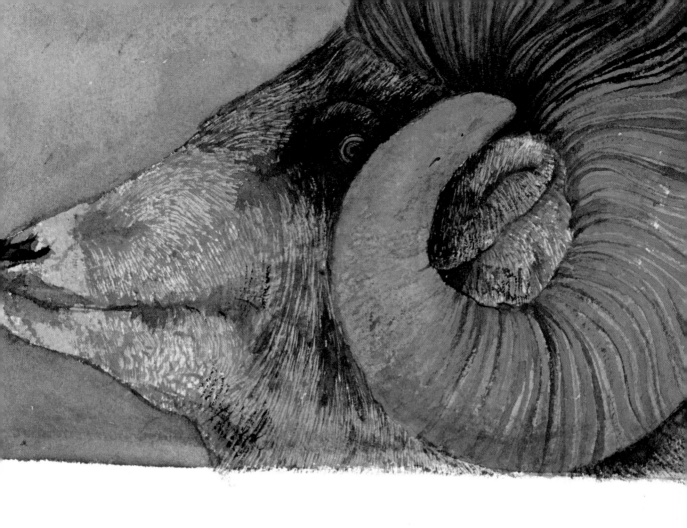

WALRUS

The walrus
Oblivious to the white-capped spatter of the sea
Ponders the splendid noise of life.

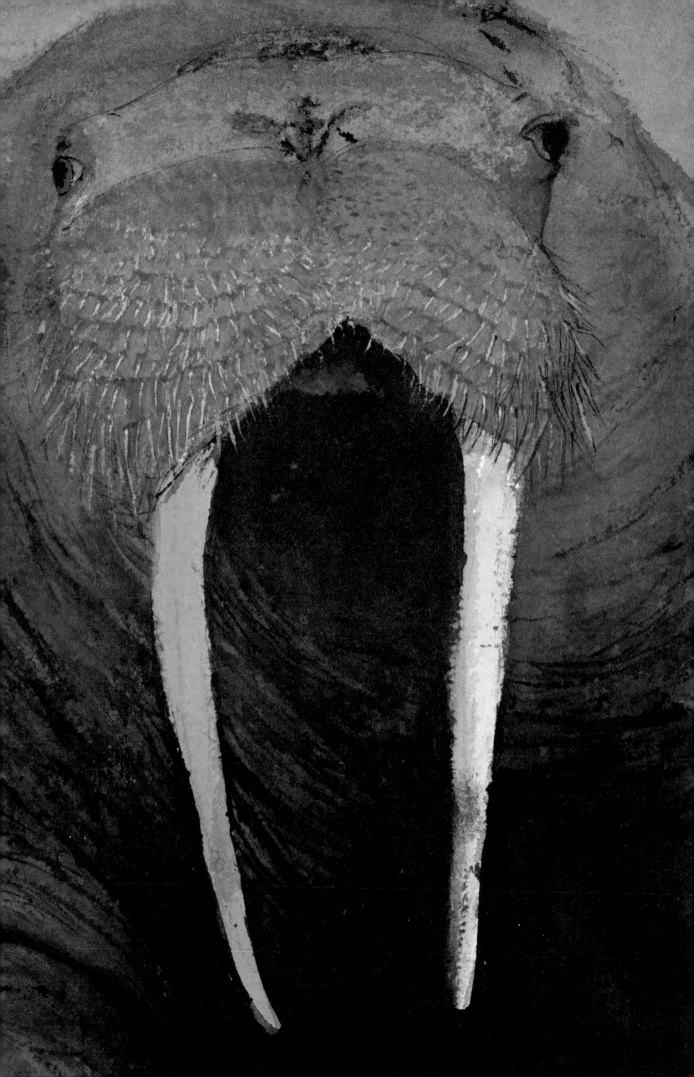

TREE PORCUPINE

Serpentine hair that billows and shines
Twines round the spines of the tree porcupine.

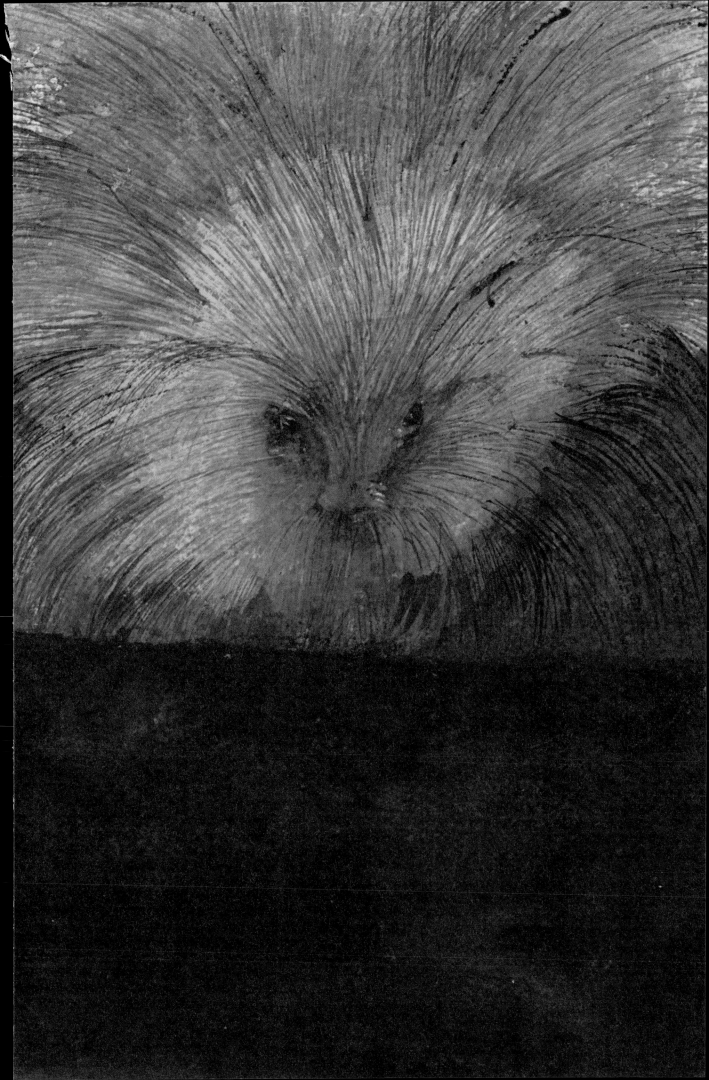

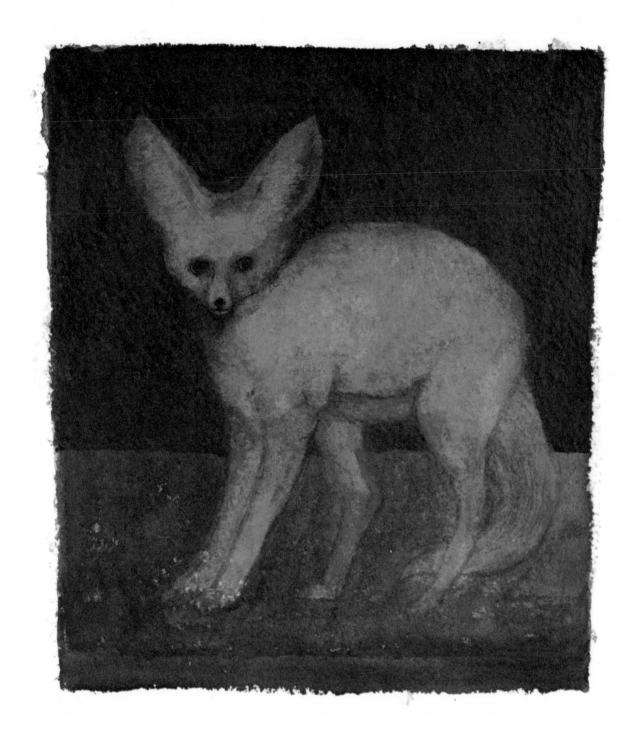

FENNEC FOX

The fennec fox, intent,
Hearing a footfall on the waves of vast Saharan sand.

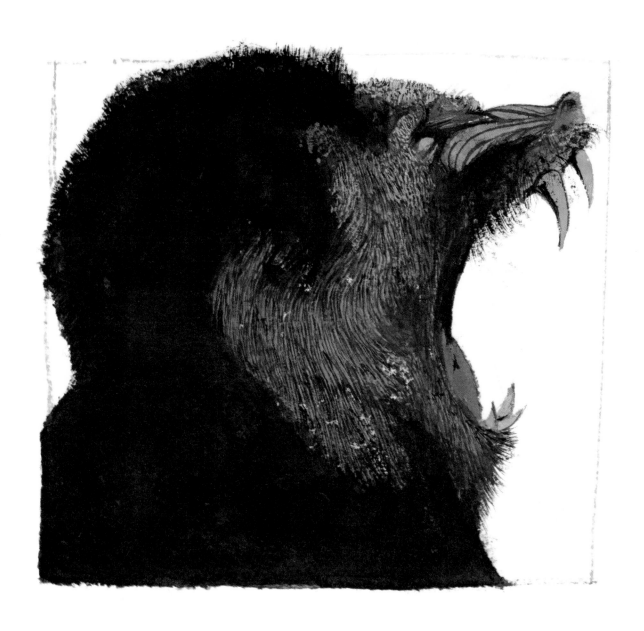

MANDRILL

The mandrill's gaping mouth houses,
Ever contending,
tempestuously whirling,
Scream, Yawn, Sing, and Bite.

AARDVARK

The portly aardvark, disdaining vulgarity,
Devises sonnets of wisdom and clarity,
While little delicate nose hairs, groomed greaselessly,
Over the termites, for dinner, loom ceaselessly.

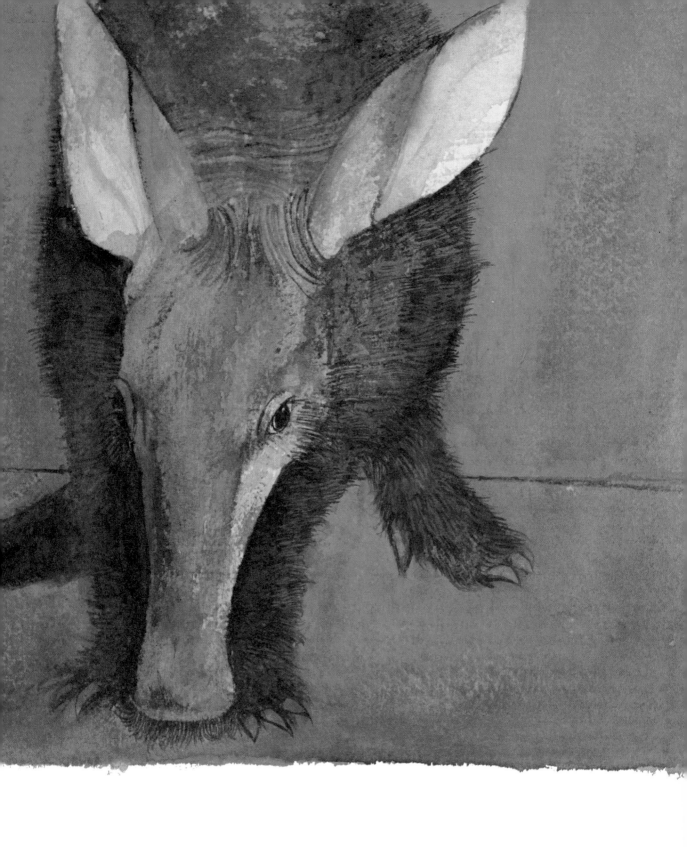

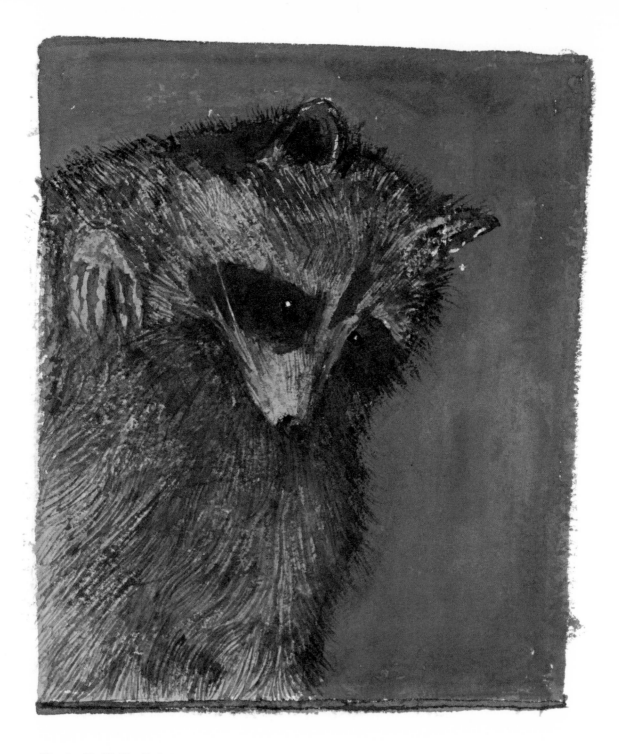

RACCOON

The raccoon

 Steeped in starlight.

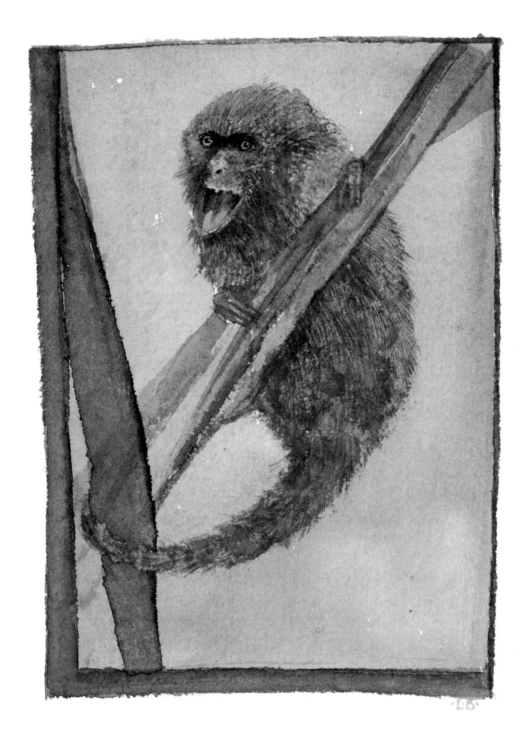

PYGMY MARMOSET

The pygmy marmoset's minuscule lips
Spew shrieking taunts, fierce orations, and quips.

CAPE BUFFALO

Never say no

 To the cape buffalo.

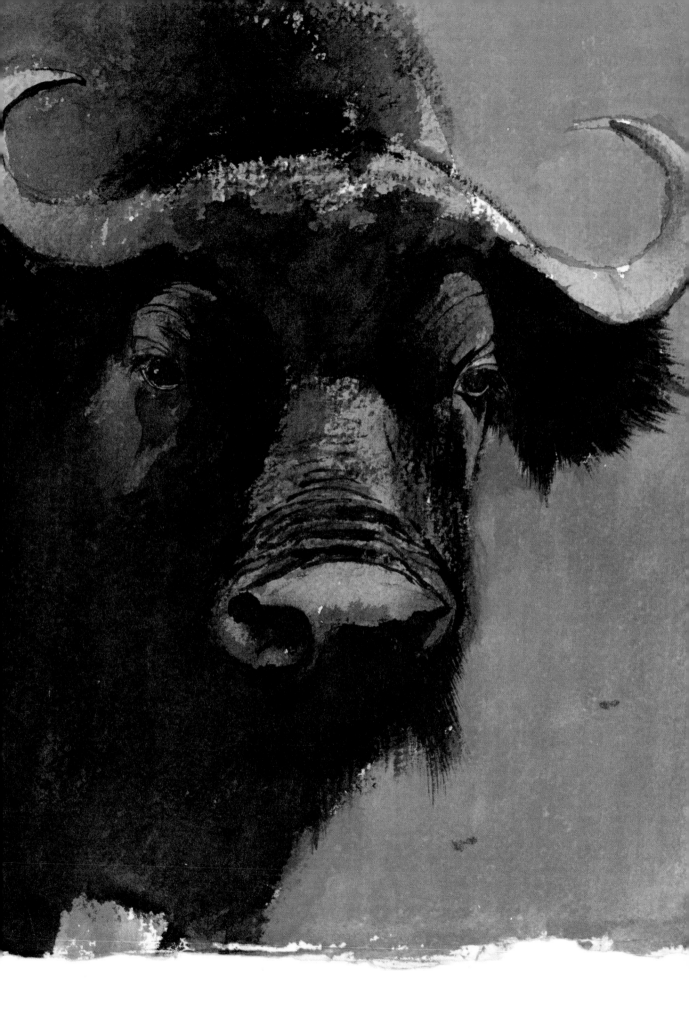

About the Book

The paintings for HOSIE'S ZOO were prepared
in watercolor and pen on pasteless board
watercolor paper hand-made in England by Barcham
Green. The art was then camera separated and
printed in four colors. The text type is
20 point Aldus Roman and Italic and
the display type is Centaur.